STEAL LIKE AN ARTIST

10 THINGS NOBODY TOLD YOU ABOUT BEING CREATIVE

AUSTIN KLEON

WORKMAN PUBLISHING COMPANY · NEW YORK

Library of Congress Cataloging-in-Publication Data is available.

ISBN 978-0-7611-6925-3

Design by Lidija Tomas with Galen Smith and Orlando Adiao

Cover by Austin Kleon

Workman books are available at special discounts when purchased in
bulk for premiums and sales promotions as well as for fundraising or
educational use. Special editions or book excerpts can also be created
to specification. For details, contact the Special Sales Director at
specialmarkets@workman.com.

Workman Publishing Co., Inc.
225 Varick Street
New York, NY 10014-4381

workman.com

Printed in China on paper from responsible sources

First printing March 2012

30 29 28

For Boom—

whenever Boom gets here

"Art is theft."

—*Pablo Picasso*

"Immature poets imitate; mature poets steal; bad poets deface what they take, and good poets make it into something better, or at least something different. The good poet welds his theft into a whole of feeling which is unique, utterly different from that from which it was torn."

—*T. S. Eliot*

19-YEAR-OLD ME
COULD USE SOME
ADVICE...

ALL ADVICE IS AUTOBIOGRAPHICAL.

It's one of my theories that when people give you advice, they're really just talking to themselves in the past.

This book is me talking to a previous version of myself.

These are things I've learned over almost a decade of trying to figure out how to make art, but a funny thing happened when I started sharing them with others—I realized that they aren't just for artists. They're for everyone.

These ideas apply to anyone who's trying to inject some creativity into their life and their work. (That should describe all of us.)

In other words: This book is for you.
Whoever you are, whatever you make.

Let's get started.

LIKE
ARTIST.

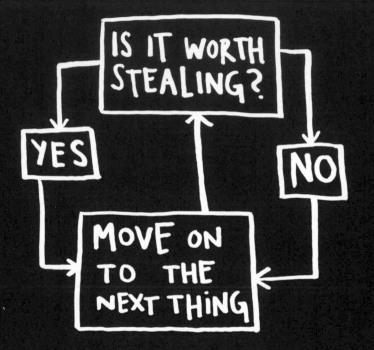

HOW TO LOOK AT THE WORLD (LIKE AN ARTIST)

Every artist gets asked the question,

"Where do you get your ideas?"

The honest artist answers,

"I steal them."

How does an artist look at the world?

First, you figure out what's worth stealing, then you move on to the next thing.

That's about all there is to it.

When you look at the world this way, you stop worrying about what's "good" and what's "bad"—there's only stuff worth stealing, and stuff that's not worth stealing.

Everything is up for grabs. If you don't find something worth stealing today, you might find it worth stealing tomorrow or a month or a year from now.

"The only art I'll ever study is stuff that I can steal from."

—David Bowie

NOTHING IS ORIGINAL.

The writer Jonathan Lethem has said that when people call something "original," nine out of ten times they just don't know the references or the original sources involved.

What a good artist understands is that nothing comes from nowhere. All creative work builds on what came before. Nothing is completely original.

It's right there in the Bible: "There is nothing new under the sun." (Ecclesiastes 1:9)

Some people find this idea depressing, but it fills me with hope. As the French writer André Gide put it, "Everything that needs to be said has already been said. But, since no one was listening, everything must be said again."

If we're free from the burden of trying to be completely original, we can stop trying to make something out of nothing, and we can embrace influence instead of running away from it.

"What is originality?
Undetected plagiarism."

—William Ralph Inge

THE GENEALOGY of IDEAS

Every new idea is just a mashup or a remix of one or more previous ideas.

Here's a trick they teach you in art school. Draw two parallel lines on a piece of paper:

How many lines are there?

There's the first line, the second line, but then there's a line of negative space that runs between them.

See it? 1 + 1 = 3.

A good example is genetics. You have a mother and you have a father. You possess features from both of them, but the sum of you is bigger than their parts. You're a remix of your mom and dad and all of your ancestors.

Just as you have a familial genealogy, you also have a genealogy of ideas. You don't get to pick your family, but you can pick your teachers and you can pick your friends and you can pick the music you listen to and you can pick the books you read and you can pick the movies you see.

You are, in fact, a mashup of what you choose to let into your life. You are the sum of your influences. The German writer Goethe said, "We are shaped and fashioned by what we love."

"We were kids without fathers . . . so we found our fathers on wax and on the streets and in history. We got to pick and choose the ancestors who would inspire the world we were going to make for ourselves."

—Jay-Z

GARBAGE IN, GARBAGE OUT.

The artist is a collector. Not a hoarder, mind you, there's a difference: Hoarders collect indiscriminately, artists collect selectively. They only collect things that they really love.

There's an economic theory out there that if you take the incomes of your five closest friends and average them, the resulting number will be pretty close to your own income.

I think the same thing is true of our idea incomes. You're only going to be as good as the stuff you surround yourself with. My mom used to say to me, "Garbage in, garbage out." It used to drive me nuts. But now I know what she meant.

Your job is to collect good ideas. The more good ideas you collect, the more you can choose from to be influenced by.

"Steal from anywhere that resonates with inspiration or fuels your imagination. Devour old films, new films, music, books, paintings, photographs, poems, dreams, random conversations, architecture, bridges, street signs, trees, clouds, bodies of water, light and shadows. Select only things to steal from that speak directly to your soul. If you do this, your work (and theft) will be authentic."

—*Jim Jarmusch*

CLIMB YOUR OWN FAMILY TREE.

Marcel Duchamp said, "I don't believe in art. I believe in artists." This is actually a pretty good method for studying—if you try to devour the history of your discipline all at once, you'll choke.

Instead, chew on one thinker—writer, artist, activist, role model—you really love. Study everything there is to know about that thinker. Then find three people that thinker loved, and find out everything about them. Repeat this as many times as you can. Climb up the tree as far as you can go. Once you build your tree, it's time to start your own branch.

START

Seeing yourself as part of a creative lineage will help you feel less alone as you start making your own stuff. I hang pictures of my favorite artists in my studio. They're like friendly ghosts. I can almost feel them pushing me forward as I'm hunched over my desk.

The great thing about dead or remote masters is that they can't refuse you as an apprentice. You can learn whatever you want from them. They left their lesson plans in their work.

read deeply

should stay open.

continue to wonder

Google

i t

y o

SCHOOL YOURSELF.

School is one thing. Education is another. The two don't always overlap. Whether you're in school or not, it's always your job to get yourself an education.

You have to be curious about the world in which you live. Look things up. Chase down every reference. Go deeper than anybody else—that's how you'll get ahead.

Google everything. I mean everything. Google your dreams, Google your problems. Don't ask a question before you Google it. You'll either find the answer or you'll come up with a better question.

"Whether I went to school or not, I would always study."

—RZA

Always be reading. Go to the library. There's magic in being surrounded by books. Get lost in the stacks. Read bibliographies. It's not the book you start with, it's the book that book leads you to.

Collect books, even if you don't plan on reading them right away. Nothing is more important than an unread library.

Don't worry about doing research. Just search.

SAVE YOUR THEFTS FOR LATER.

Carry a notebook and a pen with you wherever you go. Get used to pulling it out and jotting down your thoughts and observations. Copy your favorite passages out of books. Record overheard conversations. Doodle when you're on the phone.

Go to whatever lengths necessary to make sure you always have paper on you. Artist David Hockney had all the inside pockets of his suit jackets tailored to fit a sketchbook. The musician Arthur Russell liked to wear shirts with two front pockets so he could fill them with scraps of score sheets.

Keep a swipe file. It's just what it sounds like—a file to keep track of the stuff you've swiped from others. It can be digital or analog—it doesn't matter what form it takes, as long as it works. You can keep a scrapbook and cut and paste things into it, or you can just take pictures of things with your camera phone.

See something worth stealing? Put it in the swipe file. Need a little inspiration? Open up the swipe file.

Newspaper reporters call this a "morgue file"—I like that name even better. Your morgue file is where you keep the dead things that you'll later reanimate in your work.

"It is better to take what does not belong to you than to let it lie around neglected."

—*Mark Twain*

② DON'T
YOU KNOW
ARE TO GET

MAKE THINGS, KNOW THYSELF.

If I'd waited to know who I was or what I was about before I started "being creative," well, I'd still be sitting around trying to figure myself out instead of making things. In my experience, it's in the act of making things and doing our work that we figure out who we are.

You're ready. Start making stuff.

You might be scared to start. That's natural. There's this very real thing that runs rampant in educated people. It's called "impostor syndrome."

woj !!

The clinical definition is a "psychological phenomenon in which people are unable to internalize their accomplishments." It means that you feel like a phony, like you're just winging it, that you really don't have any idea what you're doing.

Guess what: None of us do. Ask anybody doing truly creative work, and they'll tell you the truth: They don't know where the good stuff comes from. They just show up to do their thing. Every day.

FAKE IT 'TIL YOU MAKE IT.

Have you ever heard of dramaturgy? It's a fancy term for something William Shakespeare spelled out in his play *As You Like It* about 400 years ago:

All the world's a stage,

And all the men and women merely players:

They have their exits and their entrances;

And one man in his time plays many parts.

Another way to say this? *Fake it 'til you make it.*

I love this phrase. There are two ways to read it:

1. Pretend to be something you're not until you are—fake it until you're successful, until everybody sees you the way you want them to; or

2. Pretend to be making something until you actually make something.

I love both readings—you have to dress for the job you want, not the job you have, and you have to start doing the work you want to be doing.

I also love the book *Just Kids* by the musician Patti Smith. It's a story about how two friends who wanted to be artists moved to New York. You know how they learned to be artists?

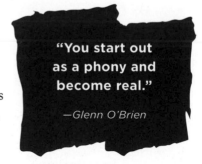

"You start out as a phony and become real."

—Glenn O'Brien

THE SCRIPT

THE PROPS

THE STAGE

They pretended to be artists. In my favorite scene, from which the book gets its title, Patti Smith and her friend, the photographer Robert Mapplethorpe, dress up in all their hippie gear and go to Washington Square Park, where everybody's hanging out. This old touristy couple is gawking at them. The wife says to her husband, "Oh, take their picture. I think they're artists." "Oh, go on," the husband disagrees. "They're just kids."

The point is: All the world's a stage. Creative work is a kind of theater. The stage is your studio, your desk, or your workstation. The costume is your outfit—your painting pants, your business suit, or that funny hat that helps you think. The props are your materials, your tools, and your medium. The script is just plain old time. An hour here, or an hour there—just time measured out for things to happen.

Fake it 'til you make it.

START COPYING.

Nobody is born with a style or a voice. We don't come out of the womb knowing who we are. In the beginning, we learn by pretending to be our heroes. We learn by copying.

We're talking about practice here, not plagiarism—plagiarism is trying to pass someone else's work off as your own. Copying is about reverse-engineering. It's like a mechanic taking apart a car to see how it works.

> "Start copying what you love. Copy copy copy copy. At the end of the copy you will find your self."
>
> —*Yohji Yamamoto*

THE HUMAN HAND IS INCAPABLE of MAKING A PERFECT COPY.

We learn to write by copying down the alphabet. Musicians learn to play by practicing scales. Painters learn to paint by reproducing masterpieces.

Remember: Even The Beatles started as a cover band. Paul McCartney has said, "I emulated Buddy Holly, Little Richard, Jerry Lee Lewis, Elvis. We all did." McCartney and his partner John Lennon became one of the greatest songwriting teams in history, but as McCartney recalls, they only started writing their own songs "as a way to avoid other bands being able to play our set." As Salvador Dalí said, "Those who do not want to imitate anything, produce nothing."

First, you have to figure out who to copy. Second, you have to figure out what to copy.

Who to copy is easy. You copy your heroes—the people you love, the people you're inspired by, the people you want to be. The songwriter Nick Lowe says, "You start out by rewriting your hero's catalog." And you don't just steal

from one of your heroes, you steal from all of them. The writer Wilson Mizner said if you copy from one author, it's plagiarism, but if you copy from many, it's research. I once heard the cartoonist Gary Panter say, "If you have one person you're influenced by, everyone will say you're the next whoever. But if you rip off a hundred people, everyone will say you're so original!"

What to copy is a little bit trickier. Don't just steal the style, steal the thinking behind the style. You don't want to look like your heroes, you want to see like your heroes.

The reason to copy your heroes and their style is so that you might somehow get a glimpse into their minds. That's what you really want—to internalize their way of looking at the world. If you just mimic the surface of somebody's work without understanding where they are coming from, your work will never be anything more than a knockoff.

IMITATION IS NOT FLATTERY.

"We want you to take from us. We want you, at first, to steal from us, because you can't steal. You will take what we give you and you will put it in your own voice and that's how you will find your voice. And that's how you begin. And then one day someone will steal from you."

—Francis Ford Coppola

At some point, you'll have to move from imitating your heroes to emulating them. Imitation is about copying. Emulation is when imitation goes one step further, breaking through into your own thing.

"There isn't a move that's a new move." The basketball star Kobe Bryant admitted that all of his moves on the court were stolen from watching tapes of his heroes. But initially, when Bryant stole a lot of those moves, he realized he couldn't completely pull them off because he didn't have the same body type as the guys he was thieving from. He had to adapt the moves to make them his own.

Conan O'Brien has talked about how comedians try to emulate their heroes, fall short, and end up doing their own thing. Johnny Carson tried to be Jack Benny but ended up Johnny Carson. David Letterman tried to copy Johnny Carson but ended up David Letterman. And Conan O'Brien tried to be David Letterman but ended up Conan O'Brien. In O'Brien's words, "It is our failure to become

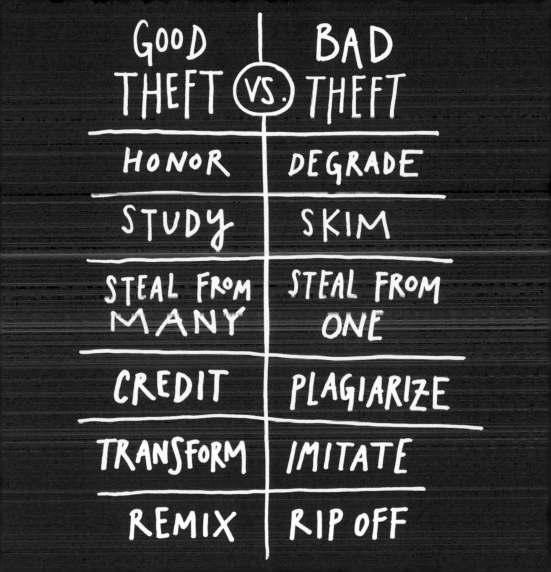

"I have stolen all of these moves from all these great players. I just try to do them proud, the guys who came before, because I learned so much from them. It's all in the name of the game. It's a lot bigger than me."

—Kobe Bryant

our perceived ideal that ultimately defines us and makes us unique." Thank goodness.

A wonderful flaw about human beings is that we're incapable of making perfect copies. Our failure to copy our heroes is where we discover where our own thing lives. That is how we evolve.

So: Copy your heroes. Examine where you fall short. What's in there that makes you different? That's what you should amplify and transform into your own work.

In the end, merely imitating your heroes is not flattering them. Transforming their work into something of your own is how you flatter them. Adding something to the world that only you can add.

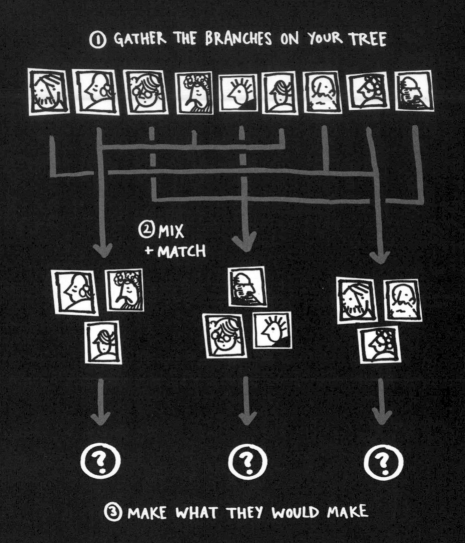

WRITE WHAT you K̶N̶O̶W̶ LIKE.

The movie *Jurassic Park* came out on my tenth birthday. I loved it. The minute I left the theater, I was dying for a sequel, so I sat down the next day at our old PC and typed one out. In my treatment, the son of the game warden eaten by Velociraptors goes back to the island with the granddaughter of the guy who built the park. One of them wants to destroy the rest of the park, the other wants to save it. Of course, they fall in love and adventures ensue.

I didn't know it at the time, but I was writing what we now call fan fiction—fictional stories based on characters that already exist.

Ten-year-old me saved the story to the hard drive. A few years later, *Jurassic Park II* finally came out. And it sucked. The sequel always sucks compared to the sequel in our heads.

The question every young writer at some point asks is: "What should I write?" And the standard answer is, "Write what you know." This advice always leads to terrible stories in which nothing interesting happens.

"My interest in making music has been to create something that does not exist that I would like to listen to. I wanted to hear music that had not yet happened, by putting together things that suggested a new thing which did not yet exist."

—Brian Eno

We make art because we like art. We're drawn to certain kinds of work because we're inspired by people doing that work. All fiction, in fact, is fan fiction.

The best advice is not to write what you know, it's to write what you like. Write the kind of story you like best—write the story you want to read. The same principle applies to your life and your career: Whenever you're at a loss for what move to make next, just ask yourself, "What would make a better story?"

Bradford Cox, a member of the band Deerhunter, says that when he was a kid he didn't have the Internet, so he had to wait until the official release day to hear his favorite band's new album. He had a game he would play: He would sit down and record a "fake" version of what he wanted the new album to sound like. Then, when the album came out, he would compare the songs he'd written with the songs on the real album. And what do you know, many of these songs eventually became Deerhunter songs.

When we love a piece of work, we're desperate for more. We crave sequels. Why not channel that desire into something productive?

Think about your favorite work and your creative heroes. What did they miss? What didn't they make? What could've been made better? If they were still alive, what would they be making today? If all your favorite makers got together and collaborated, what would they make with you leading the crew?

Go make that stuff.

The manifesto is this: Draw the art you want to see, start the business you want to run, play the music you want to hear, write the books you want to read, build the products you want to use—do the work you want to see done.

> "We don't know where we get our ideas from. What we do know is that we do not get them from our laptops."
>
> —*John Cleese*

STEP AWAY FROM THE SCREEN.

My favorite cartoonist, Lynda Barry, has this saying: "In the digital age, don't forget to use your digits!" Your hands are the original digital devices. Use them.

While I love my computer, I think computers have robbed us of the feeling that we're actually making things. Instead, we're just typing keys and clicking mouse buttons. This is why so-called knowledge work seems so abstract. The artist Stanley Donwood, who's made all the album artwork for the band Radiohead, says computers are alienating because they put a sheet of glass between you and whatever is happening. "You never really get to touch anything that you're doing unless you print it out," Donwood says.

Just watch someone at their computer. They're so still, so immobile. You don't need a scientific study (of which there are a few) to tell you that sitting in front of a computer all day is killing you, and killing your work. We need to move, to feel like we're making something with our bodies, not just our heads.

Work that only comes from the head isn't any good. Watch a great musician play a show. Watch a great leader give a speech. You'll see what I mean.

You need to find a way to bring your body into your work. Our nerves aren't a one-way street—our bodies can tell our brains as much as our brains tell our bodies. You know that phrase, "going through the motions"? That's what's so great about creative work: If we just start going through the motions, if we strum a guitar, or shuffle sticky notes around a conference table, or start kneading clay, the motion kickstarts our brain into thinking.

ART THAT ONLY COMES FROM THE HEAD
ISN'T ANY GOOD.

"I have stared long enough at the glowing flat rectangles of computer screens. Let us give more time for doing things in the real world . . . plant a plant, walk the dogs, read a real book, go to the opera."

—Edward Tufte

When I was in creative writing workshops in college, everything we did had to be double-spaced and in Times New Roman font. And my stuff was just terrible. Writing ceased to be any fun for me. The poet Kay Ryan says, "In the old days before creative writing programs, a workshop was a place, often a basement, where you sawed or hammered, drilled or planed something." The writer Brian Kiteley says he tries to make his workshops true to the original sense of the word: "a light, airy room full of tools and raw materials where most of the work is hands-on."

It wasn't until I started bringing analog tools back into my process that making things became fun again and my work started to improve. For my first book, *Newspaper Blackout*, I tried to make the process as hands-on as possible. Every poem in that book was made with a newspaper article and a permanent marker. The process engaged most of my senses: the feel of newsprint in my hands, the sight of words disappearing under my lines, the faint squeak of the marker

tip, the smell of the marker fumes—there was a kind of magic happening. When I was making the poems, it didn't feel like work. It felt like play.

The computer is really good for editing your ideas, and it's really good for getting your ideas ready for publishing out into the world, but it's not really good for generating ideas. There are too many opportunities to hit the delete key. The computer brings out the uptight perfectionist in us—we start editing ideas before we have them. The cartoonist Tom Gauld says he stays away from the computer until he's done most of the thinking for his strips, because once the computer is involved, "things are on an inevitable path to being finished. Whereas in my sketchbook the possibilities are endless."

When it came time to sequence *Newspaper Blackout*, I scanned all the pieces into a computer and printed them out on little quarter sheets of paper. Then I pushed the sheets of paper all over my office, rearranging them into piles, and then a stack, the order of which I copied back

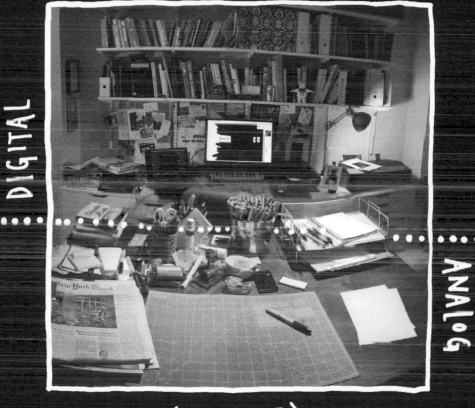

DIGITAL

ANALOG

(MY OFFICE)

onto the computer. That's how the book was made—hands first, then computer, then hands, then computer. A kind of analog-to-digital loop.

That's how I try to do all my work now. I have two desks in my office—one is "analog" and one is "digital." The analog desk has nothing but markers, pens, pencils, paper, index cards, and newspaper. Nothing electronic is allowed on that desk. This is where most of my work is born, and all over the desk are physical traces, scraps, and residue from my process. (Unlike a hard drive, paper doesn't crash.) The digital desk has my laptop, my monitor, my scanner, and my drawing tablet. This is where I edit and publish my work.

Try it: If you have the space, set up two workstations, one analog and one digital. For your analog station, keep out anything electronic. Take $10, go to the school supply aisle of your local store, and pick up some paper, pens, and sticky notes. When you get back to your analog station, pretend it's craft time. Scribble on paper, cut it up, and tape the

pieces back together. Stand up while you're working. Pin things on the walls and look for patterns. Spread things around your space and sort through them.

Once you start getting your ideas, then you can move over to your digital station and use the computer to help you execute and publish them. When you start to lose steam, head back to the analog station and play.

⑤ SIDE

AND

ARE

PROJECTS

HOBBIES

IMPORTANT.

"The work you do while you procrastinate is probably the work you should be doing for the rest of your life."

—Jessica Hische

PRACTICE PRODUCTIVE PROCRASTINATION.

One thing I've learned in my brief career: It's the side projects that really take off. By side projects I mean the stuff that you thought was just messing around. Stuff that's just play. That's actually the good stuff. That's when the magic happens.

I think it's good to have a lot of projects going at once so you can bounce between them. When you get sick of one project, move over to another, and when you're sick of that one, move back to the project you left. Practice productive procrastination.

glance out the window

stroll the streets

G O

outside

eat a sandwich

Take time to be bored. One time I heard a coworker say, "When I get busy, I get stupid." Ain't that the truth. Creative people need time to just sit around and do nothing. I get some of my best ideas when I'm bored, which is why I never take my shirts to the cleaners. I love ironing my shirts—it's so boring, I almost always get good ideas. If you're out of ideas, wash the dishes. Take a really long walk. Stare at a spot on the wall for as long as you can. As the artist Maira Kalman says, "Avoiding work is the way to focus my mind."

Take time to mess around. Get lost. Wander. You never know where it's going to lead you.

DON'T THROW ANY OF YOURSELF AWAY.

If you have two or three real passions, don't feel like you have to pick and choose between them. Don't discard. Keep all your passions in your life. This is something I learned from the playwright Steven Tomlinson.

> "You can't connect the dots looking forward, you can only connect them looking backwards."
>
> —*Steve Jobs*

ATTENTION
Do not leave your longings unattended

Tomlinson suggests that if you love different things, you just keep spending time with them. "Let them talk to each other. Something will begin to happen."

The thing is, you can cut off a couple passions and only focus on one, but after a while, you'll start to feel phantom limb pain.

I spent my teenage years obsessed with songwriting and playing in bands, but then I decided I needed to focus on just writing, so I spent half a decade hardly playing any music at all. The phantom limb pain got worse and worse.

About a year ago I started playing in a band again. Now, I'm starting to feel whole. And the crazy thing is, rather than the music taking away from my writing, I find it interacting with my writing and making it better—I can tell that new synapses in my brain are firing, and new connections are being made. About half the people I work with are musicians (this is not uncommon in Austin, Texas), and

they're not all "creatives," either—a lot of them are account executives, developers, and the like. However, they'll all tell you the same thing: Music feeds into their work.

It's so important to have a hobby. A hobby is something creative that's just for you. You don't try to make money or get famous off it, you just do it because it makes you happy. A hobby is something that gives but doesn't take. While my art is for the world to see, music is only for me and my friends. We get together every Sunday and make noise for a couple of hours. No pressure, no plans. It's regenerative. It's like church.

Don't throw any of yourself away. Don't worry about a grand scheme or unified vision for your work. Don't worry about unity—what unifies your work is the fact that you made it. One day, you'll look back and it will all make sense.

(6) THE

DO GOOD

SHARE IT

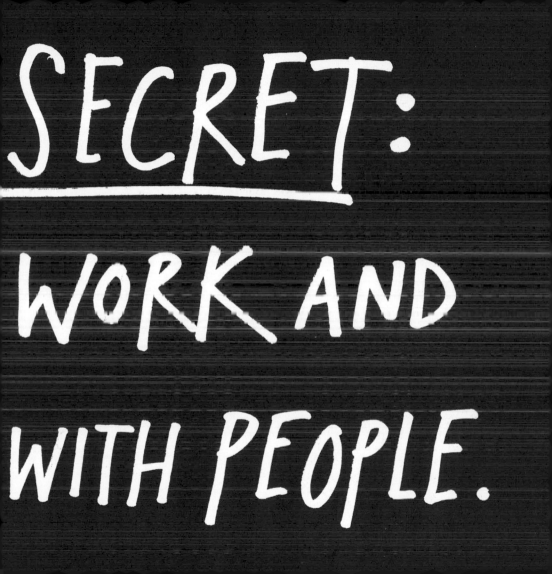

IN THE BEGINNING, OBSCURITY IS GOOD.

I get a lot of e-mails from young people who ask, "How do I get discovered?"

I sympathize with them. There is a kind of fallout that happens when you leave college. The classroom is a wonderful, if artificial, place: Your professor gets paid to pay attention to your ideas, and your classmates are paying to pay attention to your ideas. Never again in your life will you have such a captive audience.

Soon after, you learn that most of the world doesn't necessarily care about what you think. It sounds harsh, but it's true. As the writer Steven Pressfield says, "It's not that people are mean or cruel, they're just busy."

This is actually a good thing, because you want attention only after you're doing really good work. There's no pressure when you're unknown. You can do what you want. Experiment. Do things just for the fun of it. When you're unknown, there's nothing to distract you from getting better. No public image to manage. No huge paycheck on the line. No stockholders. No e-mails from your agent. No hangers-on.

You'll never get that freedom back again once people start paying you attention, and especially not once they start paying you money.

Enjoy your obscurity while it lasts. Use it.

THE NOT-SO-SECRET FORMULA

San Miguel
· doors
· dogs

Orinda
· cars
· dogs ?

If there was a secret formula for becoming known, I would give it to you. But there's only one not-so-secret formula that I know: Do good work and share it with people.

It's a two-step process. Step one, "do good work," is incredibly hard. There are no shortcuts. Make stuff every day. Know you're going to suck for a while. Fail. Get better. Step two, "share it with people," was really hard up until about ten years ago or so. Now, it's very simple: "Put your stuff on the Internet."

I tell people this, and then they ask me, "What's the secret of the Internet?"

STEP ONE:
WONDER AT
SOMETHING

STEP TWO:
INVITE OTHERS
TO WONDER
WITH YOU

Step 1: Wonder at something. **Step 2:** Invite others to wonder with you. You should wonder at the things nobody else is wondering about. If everybody's wondering about apples, go wonder about oranges. The more open you are about sharing your passions, the closer people will feel to your work. Artists aren't magicians. There's no penalty for revealing your secrets.

Believe it or not, I get a lot of inspiration from people like Bob Ross and Martha Stewart. Remember Bob Ross? The painter on PBS with the 'fro and the happy little trees? Bob Ross taught people how to paint. He gave his secrets away. Martha Stewart teaches you how to make your house and your life awesome. She gives her secrets away. People love it when you give your secrets away, and sometimes, if you're smart about it, they'll reward you by buying the things you're selling.

When you open up your process and invite people in, you learn. I've learned so much from the folks who submit

poems to my Newspaper Blackout site. I find a lot of things to steal, too. It benefits me as much as it does them.

You don't put yourself online only because you have something to say—you can put yourself online to find something to say. The Internet can be more than just a resting place to publish your finished ideas—it can also be an incubator for ideas that aren't fully formed, a birthing center for developing work that you haven't started yet.

A lot of artists worry that being online will cause them to make less work, but I've found that having a presence online is a kick in the pants. Most websites and blogs are set up to show posts in reverse-chronological order—the latest post is the first post that visitors see, so you're only as good as your last post. This keeps you on your toes, keeps you thinking about what you can post next. Having a container can inspire us to fill it. Whenever I've become lost over the years, I just look at my website and ask myself, "What can I fill this with?"

SHARE YOUR DOTS,
BUT DON'T
CONNECT THEM.

Learn to code. Figure out how to make a website. Figure out blogging. Figure out Twitter and social media and all that other stuff. Find people on the Internet who love the same things as you and connect with them. Share things with them.

You don't have to share everything—in fact, sometimes it's much better if you don't. Show just a little bit of what you're working on. Share a sketch or a doodle or a snippet. Share a little glimpse of your process. Think about what you have to share that could be of some value to people. Share a handy tip you've discovered while working. Or a link to an interesting article. Mention a good book you're reading.

If you're worried about giving your secrets away, you can share your dots without connecting them. It's your finger that has to hit the publish button. You have control over what you share and how much you reveal.

> "Don't worry about people stealing your ideas. If your ideas are any good, you'll have to ram them down people's throats."
>
> —Howard Aiken

BUILD YOUR OWN WORLD.

I grew up in the middle of a cornfield in southern Ohio. When I was a kid, all I wanted to do was get someplace where something was happening.

Now I live in Austin, Texas. A pretty hip place. Tons of artists and creative types everywhere. And you know what? I'd say that 90 percent of my mentors and peers don't live in Austin, Texas. They live *everywhere*. I know them from the Internet.

Which is to say, most of my thinking and conversation and art-related fellowship is online. Instead of a geographical art scene, I have Twitter buddies and Google Reader.

You don't have to live anywhere other than the place you are to start connecting with the world you want to be in. If you feel stuck somewhere, if you're too young or too old or too broke, or if you're somehow tied down to a place, take heart. There's a community of people out there you can connect with.

In the meantime, if you're not into the world you live in, you can build your own world around you. (Now would be a good time to put on your headphones and cue up the Beach Boys song "In My Room.") Surround yourself with books and objects that you love. Tape things up on the wall. Create your own world.

Franz Kafka wrote, "It isn't necessary that you leave home. Sit at your desk and listen. Don't even listen, just wait. Don't wait, be still and alone. The whole world will offer itself to you." And Kafka was born a century before the Internet!

ENJOY CAPTIVITY.

All you need is a little space and a little time—a place to work, and some time to do it; a little self-imposed solitude and temporary captivity. If your living situation doesn't allow for that, sometimes you can find solitude and captivity in the wild. When I was a kid, my mom used to drag me to the mall. Before she did any shopping, she took me to the bookstore and bought me any book I wanted. We'd go into stores and I would sit in a chair and read my book while she shopped. This went on for years. I read a lot of books.

Now I have a car and a mobile phone. I'm always connected, never alone or captive. So, I ride the bus to and from work, even though it's 20 minutes faster to drive. I go to a barbershop that's first-come, first-served, without Wi-Fi, and always busy with a wait of a few hours. I keep my laptop shut down at the airport. I hang out in the library.

I always carry a book, a pen, and a notepad, and I always enjoy my solitude and temporary captivity.

LEAVE HOME.

"Distance and difference are the secret tonic of creativity. When we get home, home is still the same. But something in our mind has been changed, and that changes everything."

—Jonah Lehrer

To say that geography is no longer our master isn't to say that place isn't important. Where we choose to live still has a huge impact on the work we do.

At some point, when you can do it, you have to leave home. You can always come back, but you have to leave at least once.

Your brain gets too comfortable in your everyday surroundings. You need to make it uncomfortable. You need to spend some time in another land, among people that do things differently than you. Travel makes the world look new, and when the world looks new, our brains work harder.

The time I was lucky enough to spend living in Italy and England when I was 19 and 20 certainly changed my life, but I would note that a foreign culture isn't necessarily across the sea or in another country—for most folks who grew up where I grew up, Texas might as well be Mars. (I've lived here a while. Sometimes it still feels like Mars.)

If we know we need to leave home, where should we go? Where should we choose to live? There's a bunch of different factors to consider, all of them depend on your own tastes. Personally, I think bad weather leads to better art. You don't want to go outside, so you stay inside and work. When I lived in Cleveland, I got a lot of work done in the brutal months of winter. Down here in Texas, I get all my work done in the wicked hot summers. (The Cleveland winter and the Texas summer last about the same length of time—half the year.)

It helps to live around interesting people, and not necessarily people who do what you do. I feel a little incestuous when I hang out with only writers and artists, so I enjoy the many filmmakers, musicians, and tech geeks who live in Austin. Oh, and food. The food should be good. You have to find a place that feeds you—creatively, socially, spiritually, and literally.

Even if you set up a new home, you need to leave it now and then. And at some point, you might need to just move on. The good news is that nowadays, a lot of your peers are right where you left them—on the Internet.

⑧ BE
(THE
A SMALL

MAKE FRIENDS, IGNORE ENEMIES.

**There's only one reason I'm here:
I'm here to make friends.**

The golden rule is even more golden in our hyperconnected world. An important lesson to learn: If you talk about someone on the Internet, they will find out. Everybody has a Google alert on their name. The best way to vanquish your enemies on the Internet? Ignore them. The best way to make friends on the Internet? Say nice things about them.

"There's only one rule I know of: You've got to be kind."

—*Kurt Vonnegut*

STAND NEXT TO THE TALENT.

"The only mofos in my circle are people that I can learn from."

—*Questlove*

Remember "garbage in, garbage out"? You're only going to be as good as the people you surround yourself with. In the digital space, that means following the best people online— the people who are way smarter and better than you, the

YOU WILL NEED:

- ☐ CURIOSITY

- ☐ KINDNESS

- ☐ STAMINA

- ☐ A WILLINGNESS
 TO LOOK STUPID

people who are doing the really interesting work. Pay attention to what they're talking about, what they're doing, what they're linking to.

Harold Ramis, the actor and director most famous to people of my generation for his role as Egon in the movie *Ghostbusters,* once laid out his rule for success: "Find the most talented person in the room, and if it's not you, go stand next to him. Hang out with him. Try to be helpful." Ramis was lucky: The most talented person in the room was his friend Bill Murray.

If you ever find that you're the most talented person in the room, you need to find another room.

"QUIT PICKING FIGHTS AND GO MAKE SOMETHING."

You're going to see a lot of stupid stuff out there and you're going to feel like you need to correct it. One time I was up late on my laptop and my wife yelled at me, "Quit picking fights on Twitter and go make something!"

She was right. But anger is one of my favorite creative resources. Henry Rollins has said he is both angry and curious, and that's what keeps him moving. Some mornings, when I can't wake up, I lie in bed

and read e-mail and Twitter until my blood starts boiling and I get fired up enough to spring out of bed. But instead of wasting my anger on complaining or lashing out at people, I try to channel it into my writing and my drawing.

So go on, get angry. But keep your mouth shut and go do your work.

"Complain about the way other people make software by making software."

—Andre Torrez

WRITE FAN LETTERS.

When I was younger, I wrote a lot of fan letters and had the good fortune to hear back from several of my heroes. But I've realized that the trouble with fan letters is that there's built-in pressure for the recipient to respond. A lot of times when we write fan letters we're looking for a blessing or an affirmation. As my friend Hugh MacLeod says, "The best way to get approval is to not need it."

If you truly love somebody's work, you shouldn't need a response from them. (And if the person you want to write

to has been dead for a hundred years, you're really out of luck.) So, I recommend public fan letters. The Internet is really good for this. Write a blog post about someone's work that you admire and link to their site. Make something and dedicate it to your hero. Answer a question they've asked, solve a problem for them, or improve on their work and share it online.

Maybe your hero will see your work, maybe he or she won't. Maybe they'll respond to you, maybe not. The important thing is that you show your appreciation without expecting anything in return, and that you get new work out of the appreciation.

VALIDATION IS FOR PARKING.

"Modern art = I could do that + Yeah, but you didn't."

—Craig Damrauer

The trouble with creative work: Sometimes by the time people catch on to what's valuable about what you do, you're either a) bored to death with it, or b) dead. You can't go looking for validation from external sources. Once you put your work into the world, you have no control over the way people will react to it.

Ironically, really good work often appears to be effortless. People will say, "Why didn't I think of that?" They won't see the years of toil and sweat that went into it.

Not everybody will get it. People will misinterpret you and what you do. They might even call you names. So get comfortable with being misunderstood, disparaged, or ignored—the trick is to be too busy doing your work to care.

KEEP A PRAISE FILE.

Life is a lonely business, often filled with discouragement and rejection. Yes, validation is for parking, but it's still a tremendous boost when people say nice things about our work.

Occasionally, I have the good fortune to have something take off online, and for a week or two, I'll be swimming in Tweets and nice e-mails from people discovering my work. It's pretty wonderful. And disorienting. And a major high. But I always know that high will taper off, and a few weeks

down the road I will have a dark day when I want to quit, when I wonder why the heck I even bother with this stuff.

That's why I put every really nice e-mail I get in a special folder. (Nasty e-mails get deleted immediately.) When those dark days roll around and I need a boost, I open that folder and read through a couple e-mails. Then I get back to work. Try it: Instead of keeping a rejection file, keep a praise file. Use it sparingly—don't get lost in past glory—but keep it around for when you need the lift.

"Be regular and orderly
in your life, so that you
may be violent and
original in your work."

—Gustave Flaubert

TAKE CARE OF YOURSELF.

I'm a boring guy with a nine-to-five job who lives in a quiet neighborhood with his wife and his dog. That whole romantic image of the creative genius doing drugs and running around and sleeping with everyone is played out. It's for the superhuman and the people who want to die young. The thing is: It takes a lot of energy to be creative. You don't have that energy if you waste it on other stuff.

It's best to assume that you'll be alive for a while. (It's for this reason that Patti Smith tells young artists to go to the

dentist.) Eat breakfast. Do some push-ups. Go for long walks. Get plenty of sleep.

Neil Young sang, "It's better to burn out than to fade away." I say it's better to burn slow and see your grandkids.

STAY OUT OF DEBT.

Most people I know hate to think about money. Do yourself a favor. Learn about money as soon as you can.

My grandpa used to tell my dad, "Son, it's not the money you make, it's the money you hold on to." Make yourself a budget. Live within your means. Pack your lunch. Pinch pennies. Save as much as you can. Get the education you need for as cheap as you can get it. The art of holding on to money is all about saying no to consumer culture. Saying no to takeout, $4 lattes, and that shiny new computer when the old one still works fine.

You would like to think that

Bohemia

is

a kind of

work

make sure

how much sleep

you

get

know

money

put the
time

in

KEEP YOUR DAY JOB.

The truth is that even if you're lucky enough to make a living off doing what you truly love, it will probably take you a while to get to that point. Until then, you'll need a day job.

A day job gives you money, a connection to the world, and a routine. Freedom from financial stress also means freedom in your art. As photographer Bill Cunningham says, "If you don't take money, they can't tell you what to do."

A day job puts you in the path of other human beings. Learn from them, steal from them. I've tried to take jobs where I can learn things that I can use in my work later—my library job taught me how to do research, my Web design job taught me how to build websites, and my copywriting job taught me how to sell things with words.

The worst thing a day job does is take time away from you, but it makes up for that by giving you a daily routine in which you can schedule a regular time for your creative pursuits. *Establishing and keeping a routine can be even more important than having a lot of time.* Inertia is the death of creativity. You have to stay in the groove. When you get out of the groove, you start to dread the work, because you know it's going to suck for a while—it's going to suck until you get back into the flow.

The solution is really simple: Figure out what time you can carve out, what time you can steal, and stick to your routine. Do the work every day, no matter what. No holidays, no

sick days. Don't stop. What you'll probably find is that the corollary to Parkinson's Law is usually true: Work gets done in the time available.

Nobody's saying it's going to be fun. A lot of times it will feel as if you're living a double life. The poet Philip Larkin said the best thing to do is "try to be utterly schizoid about it all—using each personality as a refuge from the other."

The trick is to find a day job that pays decently, doesn't make you want to vomit, and leaves you with enough energy to make things in your spare time. Good day jobs aren't necessarily easy to find, but they're out there.

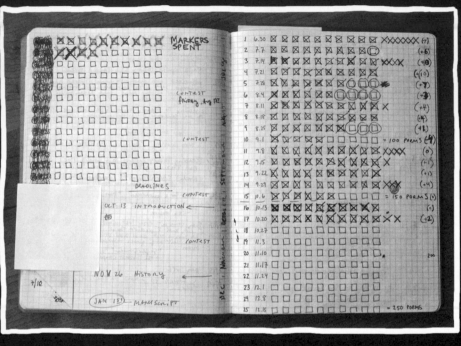

THE CALENDAR I USED FOR MY FIRST BOOK

GET YOURSELF A CALENDAR.

Amassing a body of work or building a career is a lot about the slow accumulation of little bits of effort over time. Writing a page each day doesn't seem like much, but do it for 365 days and you have enough to fill a novel. One successful client pitch is a small victory, but a few dozen of them can get you a promotion.

A calendar helps you plan work, gives you concrete goals, and keeps you on track. The comedian Jerry Seinfeld has a calendar method that helps him stick to his daily joke writing. He suggests that you get a wall calendar that shows

you the whole year. Then, you break your work into daily chunks. Each day, when you're finished with your work, make a big fat X in the day's box. Every day, instead of just getting work done, your goal is to just fill a box. "After a few days you'll have a chain," Seinfeld says. "Just keep at it and the chain will grow longer every day. You'll like seeing that chain, especially when you get a few weeks under your belt. Your only job next is to not break the chain."

**Get a calendar. Fill the boxes.
Don't break the chain.**

KEEP A LOGBOOK.

Just as you need a chart of future events, you also need a chart of past events. A logbook isn't necessarily a diary or a journal, it's just a little book in which you list the things you do every day. What project you worked on, where you went to lunch, what movie you saw. It's much easier than keeping a detailed diary, and you'd be amazed at how helpful having a daily record like this can be, especially over several years. The small details will help you remember the big details.

In the old days, a logbook was a place for sailors to keep track of how far they'd traveled, and that's exactly what you're doing—keeping track of how far your ship has sailed.

"If you ask yourself 'What's the best thing that happened today?' it actually forces a certain kind of cheerful retrospection that pulls up from the recent past things to write about that you wouldn't otherwise think about. If you ask yourself 'What happened today?' it's very likely that you're going to remember the worst thing, because you've had to deal with it—you've had to rush somewhere or somebody said something mean to you—that's what you're going to remember. But if you ask what the best thing is, it's going to be some particular slant of light, or some wonderful expression somebody had, or some particularly delicious salad."

—Nicholson Baker

SATURDAY
September 5

CLOUDY + COOL

- 4/9 pizza + indian leftovers
- walk dog, let neg sleep in
- nice + cloudy
- RAMBO on cable
- painted furniture
- fell asleep in lawn chair
- PHIL'S + beer
- TARGET ice cream
- TRUE BLOOD

SUNDAY
September 6

"gone are born to sweet delight"

AWESOME DAY.

- coffee + pb + j
- pool to ourselves
- painting furniture
- that stuff'll make yr hair fall out
- LOCKHART! fire pit
- Smitty's (★★★★★ !)
- FOOD COMA
- DEAD MAN (★★★★★) @ the Alamo by myself met Jason + Maile
- MADMEN + smoothies w/ neg

PAGES FROM MY LOGBOOK

"She rescued me. I'd be playing in a steak house right now if it wasn't for her. I wouldn't even be playing in a steak house. I'd be *cooking* in a steak house."

—Tom Waits, on his wife and collaborator, Kathleen Brennan

MARRY WELL.

Who you marry is the most important decision you'll ever make. And "marry well" doesn't just mean your life partner—it also means who you do business with, who you befriend, who you choose to be around. Relationships are hard enough, but it takes a real champion of a person to be married to someone who's obsessed with a creative pursuit. Lots of times you have to be a maid, a cook, a motivational speaker, a mother, and an editor—all at once.

A good partner keeps you grounded. A friend once remarked that living with an artist must make our house very inspiring. My wife joked, "Oh yeah, it's like living with da Vinci." She's the best.

Olympics. Sure, it could be ased, but at least it was explicable bias.

Creativity is

subtraction.

od, Tara everal for-noved on.

could
ioned

his idiosyncrasies to warm our hearts. Remember the costume he described as "a Care Bear on

it."

His to hea sponse age on regret here f You've chance al a rea

That kick Jo He ret harder to disa light.

Now Olymp. gram h gram i who fi all are Olymp.

CHOOSE WHAT TO LEAVE OUT.

In this age of information abundance and overload, those who get ahead will be the folks who figure out what to leave out, so they can concentrate on what's really important to them. Nothing is more paralyzing than the idea of limitless possibilities. The idea that you can do anything is absolutely terrifying.

The way to get over creative block is to simply place some constraints on yourself. It seems contradictory, but when it comes to creative work, limitations mean freedom. Write a song on your lunch break. Paint a painting with only one

color. Start a business without any start-up capital. Shoot a movie with your iPhone and a few of your friends. Build a machine out of spare parts. Don't make excuses for not working—make things with the time, space, and materials you have, right now.

The right constraints can lead to your very best work. My favorite example? Dr. Seuss wrote *The Cat in the Hat* with only 236 different words, so his editor bet him he couldn't write a book with only 50 different words. Dr. Seuss came back and won the bet with *Green Eggs and Ham*, one of the bestselling children's books of all time.

> "Telling yourself you have all the time in the world, all the money in the world, all the colors in the palette, anything you want—that just kills creativity."
>
> —Jack White

There are definite dangers in
thinking you can do everything.

whittle down the

stream

you can think

do
with

less

start

now

The artist Saul Steinberg said, "What we respond to in any work of art is the artist's struggle against his or her limitations." It's often what an artist chooses to leave out that makes the art interesting. What isn't shown versus what is. It's the same for people: What makes us interesting isn't just what we've experienced, but also what we haven't experienced. The same is true when you do your work: You must embrace your limitations and keep moving.

In the end, creativity isn't just the things we choose to put in, it's the things we choose to leave out.

Choose wisely.

And have fun.

WHAT NOW?

- ☐ TAKE A WALK
- ☐ START YOUR SWIPE FILE
- ☐ GO TO THE LIBRARY
- ☐ BUY A NOTEBOOK AND USE IT
- ☐ GET YOURSELF A CALENDAR
- ☐ START YOUR LOGBOOK
- ☐ GIVE A COPY OF THIS BOOK AWAY
- ☐ START A BLOG
- ☐ TAKE A NAP

RECOMMENDED
READING

- LYNDA BARRY, <u>WHAT IT IS</u>

- HUGH MacLEOD, <u>IGNORE EVERYBODY</u>

- JASON FRIED + DAVID HEINEMEIER HANSSON, <u>REWORK</u>

- LEWIS HYDE, <u>THE GIFT</u>

- JONATHAN LETHEM, <u>THE ECSTASY</u> of INFLUENCE

- DAVID SHIELDS, <u>REALITY HUNGER</u>

- SCOTT McCLOUD, <u>UNDERSTANDING COMICS</u>

- ANNE LAMOTT, <u>BIRD BY BIRD</u>

- MIHALY CSIKSZENTMIHALYI, <u>FLOW</u>

- ED EMBERLEY, <u>MAKE A WORLD</u>

Y.M.M.V.

(YOUR MILEAGE MAY VARY!)

SOME ADVICE CAN BE A VICE.

FEEL FREE TO TAKE WHAT YOU CAN USE,
AND LEAVE THE REST.

THERE ARE NO RULES.

TELL ME WHAT YOU THINK
OR SAY HELLO AT:

WWW. AUSTINKLEON .COM

"DELETED SCENES"

THIS BOOK BEGAN ITS LIFE ON INDEX CARDS.
HERE ARE SOME THAT DIDN'T MAKE IT.

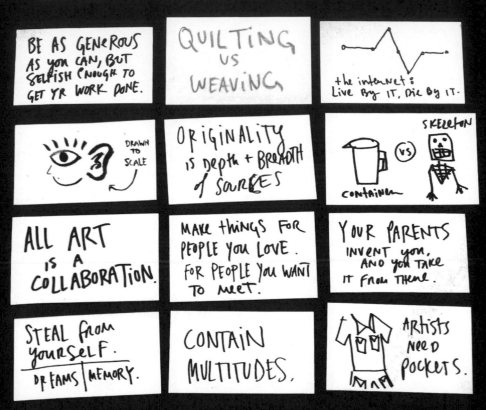

BE AS GENEROUS AS YOU CAN, BUT SELFISH ENOUGH TO GET YR WORK DONE.

QUILTING VS WEAVING

the internet: LIVE BY IT, DIE BY IT.

DRAWN TO SCALE

ORIGINALITY IS DEPTH + BREADTH OF SOURCES

SKELETON vs CONTAINER

ALL ART IS A COLLABORATION.

MAKE THINGS FOR PEOPLE YOU LOVE. FOR PEOPLE YOU WANT TO MEET.

YOUR PARENTS INVENT YOU, AND YOU TAKE IT FROM THERE.

STEAL FROM yourself. DREAMS | MEMORY.

CONTAIN MULTITUDES.

ARTISTS NEED POCKETS.

the "SO WHAT?" TEST

TIME + SPACE TRAVEL.

Contextomy
quoting out of context

GO DEEPER.

WHAT IF WE GIVE IT AWAY?

MUTATIONS
MISHEARD LYRICS
IMPERFECT COPIES FROM MEMORY

INFLUENCE IS ACTIVE, NOT PASSIVE.

CONFUSED, BUT NOT CONFOUNDED.
misreadings are a source of original inspiration

WHAT DO YOU WANT YOUR DAY TO LOOK LIKE?

ALWAYS BE READING
A BOOK IS A LENS TO SEE THE WORLD THROUGH.

WONDERING WANDERING

STAY AWAY FROM MATCHES

DO IT WRONG.

MAKE IT STRANGE.
YOUR INSTRUMENTS LIKE LEGO BRICKS.

I CAME TO TEXAS FOR THE MYTHOLOGY.

10 YEARS

CAN AFTER

This book began its life thanks to a blog post that went "viral," so it feels darkly appropriate to be writing its afterword during a worldwide plague.

Ideas spread a lot like the plague—they thrive in networks of brains connected to other brains—but ideas only really take hold in minds that are ready to receive them and pass them on.

So why were the ideas in this book received by so many, and why has the book stuck around for over a decade?

"*Influence* and *influenza* in fact have the same etymology."

—*Elisa Gabbert*

Marshall McLuhan's editor once told him, "A successful book cannot venture to be more than ten percent new." The open secret of *Steal Like an Artist* is that it practices what it preaches, and it operates by its own principles: The book is a *collage* of other people's ideas.

Old ideas, since they've been around so long, tend to be more durable and easily accepted than new ones, and the big idea at the heart of this book—nothing is completely original—is downright *ancient*. In chapter one, I quote from Ecclesiastes, "there is nothing new under the sun," but almost two millennia before that line was written, the Egyptian poet Khakheperresenb was already complaining that the good words had been used up. The idea that there's nothing new is at least 4,000 years old.

"The only thing new is you finding out about it," says bassist Mike Watt. The problem of originality might be very old, but for every human who arrives on the planet, the problem becomes new again.

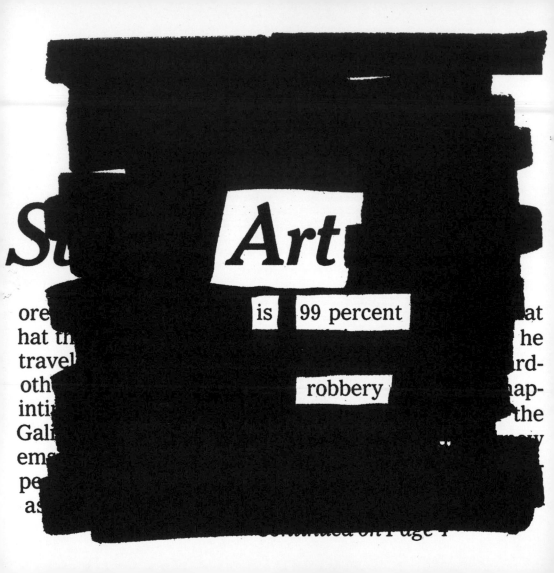

Su *Art*

is 99 percent

robbery

ore... ...at
hat th... he
travel... rd-
oth... nap-
inti... the
Gali...
em...
pe...
as...

Continued on Page 1

If you want to do anything creative, at some point you have to grapple with influence and what to do with it. The trouble is, the way we usually talk about influence is *backwards*. If I say, "Jean-Michel Basquiat was influenced by Vincent van Gogh," it makes it sound like Van Gogh was the one doing something to Basquiat, when it was actually Basquiat doing something with Van Gogh.

"Our understanding of [influence] is obstructed by the grammar of our language," wrote critic K. K. Ruthven. "In matters of influence, it is the receptor who takes the initiative, not the emitter."

"You've got to realize that influence is not influence. It's simply someone's idea going through my new mind."

—Jean-Michel Basquiat

In other words: Influence is not passive, it's *active*.

Influence is not bestowed upon you by others. Influence is something you *take*.

Which brings us to the word "steal."

From the very beginning, people have asked me why I had to use *that* word. I tell them it's because I'm not very original—the only reason I used the word was because so many artists had used it before me!

It's a provocative word. Maybe even a dangerous word. But is it the *right* word?

I like the word "steal" because it gives you a very specific and fruitful way of paying attention to the world. To be a good thief is to always be "casing the joint," looking for the next bit of inspiration.

They say there's "no honor among thieves," but there should be, and this book tries to set down a code to live by.

~~PINCH~~

~~RIP OFF~~

~~LIFT~~

~~THIEVE~~

~~PURLOIN~~

~~LOOT~~

~~SWIPE~~

~~CRIB~~

~~PLUNDER~~

~~PILLAGE~~

~~PILFER~~

~~BORROW~~

~~FILCH~~

~~APPROPRIATE~~

(STEAL)

Unfortunately, there will always be those who go too far. Some readers even take the title literally: Many a bookseller has told me this book is the most shoplifted in the store. These thieves either haven't actually read the book, or they remember the "steal" part of the title and forget the "like an artist" part. To steal like an artist is to *not get caught*! To steal like a thief is to get your hands chopped off.

G. C. Lichtenberg said a book is like a mirror: If a jerk looks in, a jerk looks out. If you know that ideas spread like the plague, you have to be ready for any ideas you release into the world to get away from you, for them to mutate, for new variants to emerge.

If the idea spreads far enough, eventually people might not even be able to trace the idea back to its source. I've seen photos of "STEAL LIKE AN ARTIST" spray-painted on brick walls and stenciled on the back of bootleg jackets in countries I've only dreamed about visiting. At this point, the phrase is more beloved and well-traveled than I am.

The ideas in this book may have spread a little *too* far. Our popular culture is overrun with endless spinoffs, sequels, and remakes, while the gigantic copy machine called the Internet spits out infinitely repeating memes. We are all "under the influence," but the influence we're under is our own. It's as though we've been locked in a stale room for too long, intoxicated by our own fumes.

T. S. Eliot said a good artist will steal from artists "remote in time, or alien in language, or diverse in interest." The artist must journey past the surface of what's being offered up and keep searching for fresh sources of inspiration.

"There are few images to be found. One has to dig for them like an archaeologist. One has to search through this ravaged landscape to find anything at all."

—*Werner Herzog*

Looking back,

I don't think that I

had

a plan

I

was just making it up

and

the

what-ifs

began

to

be

real

As much as I enjoy looking back, it's never good for a writer to spend too much time in retrospection. You can't move forward if you're looking back.

To *execute* a creative project is to carry out a kind of death sentence. I do the work of putting the words and the pictures on the page, but once I finish a book, it's pretty much dead to me.

Been there, done that.

"Once you start looking back, you have stopped moving forward; and what is proverbially said of sharks is true—at least metaphorically—of artists: if your forward momentum ceases, you die."

—Martin Gayford

It's a closed book until the reader opens it. The reader brings the words and pictures to life with their time and attention. That so many readers have continued to give this book a life is a surprise and delight. The book now belongs to y'all more than it belongs to me. It's the reason I haven't made many changes to the original: Who am *I* to change it?

There are more years between me and the me who wrote this book than between the me who wrote this book and the 19-year-old me he was writing it for. When I reread the book now, it's no longer dead to me, it's just . . . *strange.* The pages are alive, but with a force I don't recognize.

Who wrote this? I think to myself. *Who is this kid? Where did he get all his energy and confidence?*

He stole it all, obviously. Now we get to steal from him.

—June 2021, Austin, Texas

Reader:

Each time
you

handle

m e

I

come to life.

THANK YOU

To my wife, Meghan—my first reader, first everything.

.

To my agent, Ted Weinstein, my editor, Bruce Tracy, my book designer, Lidija Tomas, and all the fabulous people on the team at Workman. Y'all impress the heck out of me.

.

To all the people I've stolen from, including but not at all limited to: Lynda Barry, Ed Emberley, Hugh MacLeod, John T. Unger, Jessica Hagy, Kirby Ferguson, Maureen McHugh, Richard Nash, David Shields, Jonathan Lethem, and Chris Glass and the folks at wireandtwine.com, who let me use their "Here to Make Friends" T-shirt.

.

To my parents, Sally and Scott Kleon.

· · · · · · · · · ·

To Amy Gash, for her keen eye.

· · · · · · · · · ·

To all my lovely friends and family online and offline, who spread the original blog post around the Internet and sent me numerous sources and quotes for inspiration.

· · · · · · · · · ·

Finally, thank you very much to Broome Community College—without your invitation to speak, I might've never come up with the list.

· · · · · · · · · ·

THIS BOOK
WILL TEACH YOU
HOW TO BUILD A
MORE MEANINGFUL
AND SUSTAINABLE
CREATIVE LIFE
↓

USE THIS NOTEBOOK TO
STIMULATE YOUR CREATIVITY
AND KEEP TRACK OF
YOUR EXPLORATIONS
↓

NEW YORK TIMES
BESTSELLING
AUTHOR OF
STEAL LIKE AN
ARTIST

KEEP
GOING→

10 WAYS TO STAY CREATIVE IN GOOD TIMES AND BAD

AUSTIN KLEON

NEW YORK
TIMES
BESTSELLING
AUTHOR

THE
STEAL
LIKE AN
ARTIST
JOURNAL

A NOTEBOOK FOR
CREATIVE KLEPTOMANIACS

AUSTIN KLEON

DOODLES